D1430358

SIGNLANGUAGE

"SIGNLANGUAGE"
February 2–March 30, 2002
Track 16 Gallery
Santa Monica, California

Editor: Pilar Perez
Design: Michele Perez
Copy Editor: Sherri Schottlaender
Digital Mastering and Printing: Hugh Milstein
and Anna Bolek, Digital Fusion
Photography of paintings: William Short

Vol. VIII, no. 78
ISBN 1-889195-49-9
© 2002 Smart Art Press
© 2003 Sixth Edition
Published by Smart Art Press
2525 Michigan Avenue, Building C1
Santa Monica, CA 90404
(310) 264-4678 tel
(310) 264-4682 fax
www.track16.com

© All images, Viggo Mortensen

Distributed by RAM Publications
2525 Michigan Avenue, Building A2
Santa Monica, CA 90404
(310) 453–0043 tel
(310) 264–4888 fax
e-mail: rampub@gte.net

Cover image: *Year One,* 2000
Frontispiece: *Chetwood Forest #5,* 2000
Photograph page 82: Harriet Zucker

Printed by Jomagar, S.L., Spain

VIGGO MORTENSEN *Signlanguage*

SMART ART PRESS

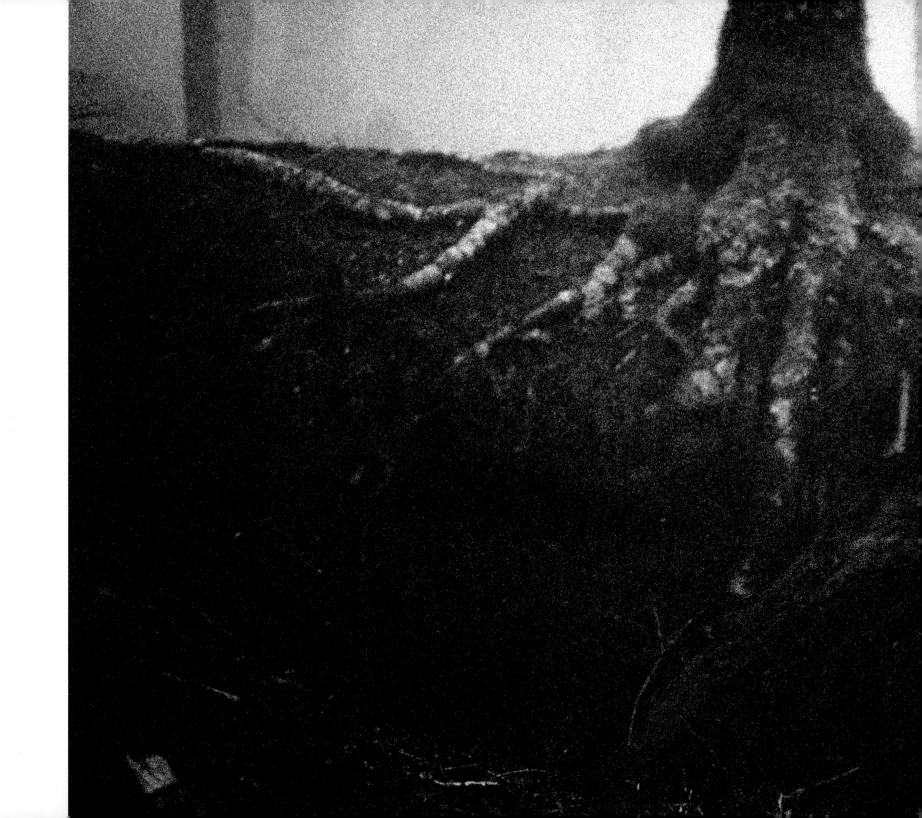

TO SEE LIFE AS A POEM
AND YOURSELF AS
PARTICIPATING IN A POEM
IS WHAT MYTH DOES FOR YOU.
—JOSEPH CAMPBELL

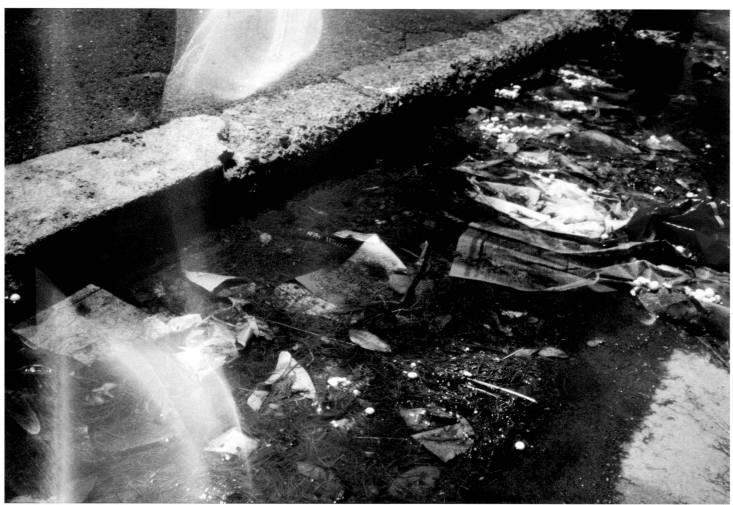

Why Wait, 2000

VIGGO MORTENSEN: A LIFE TRACKING ITSELF

KEVIN POWER

Lonely in
no one
to hold it with

the responsible
caring
for those one's known.
—Robert Creeley,
"Memories"

The impulse to re-work, the refusal to leave well-enough alone, invites creative paralysis, a state defiantly hopeless. Driving force(s) behind such incessant tampering with thought-done work cannot be justified, only endured with humour and tolerance. No one else to blame. May be on to something, though, on a golden path. Who knows. Nothing works sometimes. Ruin is always likely . . .
—Viggo Mortensen, journal entry, October 31, 2001

Last night walked uphill against the rain on Taranaki St. and then across to Tory, by Mt. Cook police station, and saw the unearthly beams emanating from the 10 ks up on Mt. Victoria.
—Viggo Mortensen, journal entry, October 30, 1999

These doors are probably governed by words.
—J. R. R. Tolkien, ('Gandalf'), *The Fellowship of the Ring*

I guess one of the intimate measures of living is how we look at things: Intimate in the sense that it shows how we relate to wherever we happen to be, and inevitably we are always somewhere; intimate in that it implies a momentary flurry of curiosity that turns into a pattern of curiosities; and intimate because it involves the adding of our own fictions to reality. We are a collection of broken attentions, a collage of words, events, functioning biology, and memories with which we conform out of some kind of temporal immediacy, necessity, and exhaustion. Here we are now, together, physically and collectively at least, a real everyday miracle. Here we are then, a hapless, irascible, quirky but contented accumulation of the partially understood and the partially registered. I remember the artist James Lee Byars telling me that he had not learned to

look until he went to Japan, that he had seen nothing carefully in the world, that he had seen it all for sale, that he had been guilty of a gross lack of attention, that he knew no names, and that his reflection was always at the end of any tunnel. You remember (or perhaps you don't, given our general incapacity to remember the particular) Louis Zukofsky's definition of "An objective: (optics)—The lens bringing the rays from an object to a focus. That which is aimed at. (Use extended to poetry)—Desire for what is objectively perfect, inextricably the direction of historic and contemporary particulars."[1] And he said it seventy years ago! Things have not changed that much, and we all still need to look at things with care, the quality of care that Heidegger argued best defined love (a sticky substance at the best of times). In short, the task is to train and polish the attention within the brilliance of our small shipwrecks. Viggo Mortensen does both insistently, and maybe obsessively; he trains his eye to find small wonders and flashes of surprise, and these things are polished by the way he frames them. It is this framing that most clearly, both formally and unconsciously, corresponds to his sense of how things are.

He is photographer, painter, and poet: a triple-time eye/I who shares with us the desire for the perfect as never more than an elusive glimpse of something that surprises us all. It seems that these moments can only be held if they appear to be escaping or yielding to what cannot last. Photography, whatever else it may be, is a focusing on detail. Mortensen likes *sotto voce* details; he gives his attention to instants that would otherwise have passed by unobserved, or more significantly, unregistered—things that in a literal sense were simply there for him because he was there for them—things that would have easily passed by as all else passes by, as we ourselves finally do. I have, with age, formed a disposition to remember with largesse and without cohesion, in grabs and incompletions, without syntax or order, not so much from any willed laziness but rather from some kind of erroneously cultivated indifference. Mortensen seems to suggest that all incidents are photographable: perhaps none carry more significance than any others, or they carry the overwhelming significance he has given them through his involvement. It is literally a matter of being involved, being present, being, as Pollock might have said, "in it," in what is happening, trusting it. He returns us to the subject as a connection through which life passes. We form the event, selecting what seems significant to us, and in so doing we literally shape ourselves through the precise energy of our attentions. The things he photographs belong to him, are of him because they happened to him, and therein lies their coherence.

It is Mikhail Bakhtin who speaks of the depth of subjectivity at a time when everybody else has almost killed off the subject: "inner infinitude breaks into the open and finds no repose: life is intensely principled." The act of bringing your eye close to any object is the beginning of a relationship. Viggo holds on tight to all that he has around him and to whatever small structures of resistance that they can build, be it moments of love, the innocence of children, curiosity, family, colors, incomplete details, juxtapositions, non sequiturs—simply, what Is. Poetry and photography are themselves just two more discourses in the world of lan-

guage—they are not as special as the twentieth century so desperately wished us to believe, but rather merely part of it.

Mortensen's work—photographs, paintings, and poems—all seems to me to be intensely autobiographical. I mean that his works are autobiographical in the sense that Robert Creeley gives to this term, "auto-bio-graphy," which he felicitously translates as "a life tracking itself."[2] What could be closer to us than that, to who we are as a constant becoming. Inevitably and invariably we follow our own footsteps and peer out through the same small cracks, allowing the world to come into a small and immediate focus, with its pains and fortunes, with its mermaids and menstruations, with its infinite deserts and abandoned bottles.

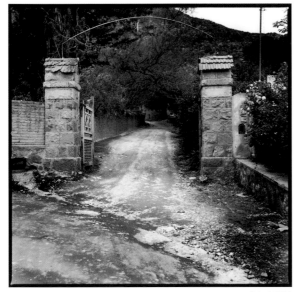

School, 1996

Viggo knows—although this may well be nothing more than my own small assertion—that we never glimpse much more than the partial; we are always dragging the truth of things out of the earth in a paradoxical yet liberating act of frustrated incompletion. He seems to know how to make do with the day's harvest: he piles things up as fragile, unassuming sensations that hold on to the passing and the significantly insignificant. Soaked in their small mysteries, these things yield up fragile glimpses of meaning. In an earlier exhibition catalogue of Mortensen's work, we find a wide-open school gate leading onto a long empty drive surrounded on both sides by hills and dense vegetation, the stretched-out nostalgia of the irremediably lost condition (*School*, 1996). A red truck with no tailgate and no driver, seen from behind, occupies the whole frame in a play of geometries, empty apart from a surfboard that echoes both the color of the vehicle and the same human absence (*Red #5*, 1998). A young tattooed man, a housepainter lost in his monochromatic labor, stands on a ladder whose shadow definitively obliterates its very presence (*Painter*, 1998). A sunny California street and a house pushed back beyond a cropped tree trunk: the same dull neutrality of house and wall speaks of unambitious and monotonous living, while the stark black house numbers stenciled on the curb suggest a prison sentence for whoever inhabits the house; enough is never quite enough, however, because in the foreground is a lone leaf in the gutter, as if in memory of some fragile passing (*1045*, 1998). These are the things of Mortensen's momentary world. They are his own defining limits, these humanly shaped materials and images, but it is not so much Mortensen's consciousness that is the shaping spirit, but rather—to use a term from sixties poetics—the "open fields" in which things can speak to one another. These open fields graph the pattern of his energies as an irruptive, projective fact in the world which finds an order and yields their meanings to the artist himself—and through him to us.

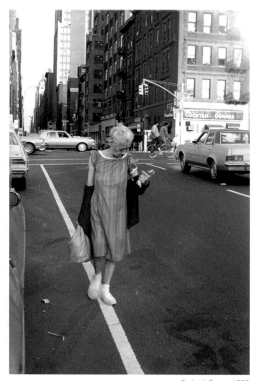

Cocktail Corner, 1985

Nothing much changes in an obvious way in Mortensen's world. Things move in and out, within a larger universe furrowed by disaffection, where devaluation is rampant and dogmas, knowledge, programs, and philosophies are losing their credibility. He is interested in what is here, not in talk about what isn't. He captures things that involve him completely, which allows a focus, however brief, on immediate understanding rather than on memory. These photos are taken with a trained impulse: the subjects seem to have waited for the photographer to feel the itch to click. These are possibilities that configure a context or moments in his life, whether he is in Amsterdam photographing on the street, working on the movie *The Lord of the Rings*, or in his own backyard. His work is rich in the materials of life, which will not let themselves be perverted into the mistruths of conventional signals or instructions to the viewer which lead to a presupposed meaning and hence obscure the artist's truth.

Unfortunately, I have not had the pleasure of meeting Viggo Mortensen, but during an exchange of notes, comments, and images I suggested that his work shows an attitude towards living. His reply was a laconic but potentially curious "What's an attitude?" I failed to reply, so let me now make an attempt to explain what I mean. We are, or serve as, the nexus points through which things pass; we're a place for sensations, images, meanings, words, people, and objects to come together. We constantly filter these facts, impressions, events, and emotions, endlessly selecting, and in many ways we ourselves are the result of those selections—whether hysterical, lazy,

indifferent, passionate, etc. Yet what makes us select this image over that image as significant? This order over that order as somehow telling? This person over that person? This act over that one? This moment of attention over the myriad of others? Most of us have no time to put a backbone behind our eye and we come too late—or perhaps never—into what might have been ourselves. What we select has a coherence precisely because we have ourselves selected it.

Life, as they say, is too short, and we fail to think things through. Robert Creeley says something that goes to the bone:

> There's a large lion in the forest,
> said the man to his wife whom he
> had thought of one night in April
> and thus married. It's me she said,
> looking at him. What does it mean:
> there's a large lion, anywhere, and
> has anybody told the lion? . . .
> I want to think for awhile of
> anything. Say birds—I like them.
> People—terrific, if they like me.
> What a great life we're having, if
> comfortable in our seats and minds
> and hearts. Or horrible, if rejected,
> unloved, in pain. I want to think it
> over. And over and over and over.
> Will thinking get me anywhere! To
> Detroit, possibly. Or here, for those
> of who came from elsewhere, truly
> another abstraction.[3]

In short, we run along with things, following this momentary version of the truth as much as defining it. For sure, when there's a lion in the house either run as fast as you can or marry it—either choice is an impetuous act for which you'll in all probability pay.

The point is to get through hell in a hurry, and Mortensen moves through the languages and locations of his life with a particular eye. He is endlessly prepared to pay small attentions—often, I am told, barefoot, as if insisting on keeping contact with the ground. Mortensen also likes people: a man on a terrace, limp hand on the balcony rail, lets the sands of time sift through; the vertical figure caught elegantly in a tight geometry of horizontals creates a subdued tone poem of gray, blue, and black (*Gray's Visit*, 2000). A woman, her lips pursed into an autumn distance, wears an earring that hangs like a large tear before the ephemeral beauty of it all (*Sandy Dennis*, 1985). An old gray-haired woman in her red dress and red shawl holds a brown paper bag perhaps containing alcohol; she is worn to the nervous edges by the relentless tide of small and large disasters, but she also has a certain frayed nobility, an anguished but irreducible clinging to her sense of self, which is set off against the gold, brown, and yellow tones that unite buildings, traffic light, and car (*Cocktail Corner*, 1985). A young woman waits for the bus, slightly absent, pensive, resistant even to the photo, moving from one place to another (*Dunedin*, 2000). A man in a plaid shirt holds a small pie, his arm raised as if to protect it, presumably from the two dogs, one of which is linked by color to the pie—as if that were the first step to claiming it (*K*, 1999). As is often the case in

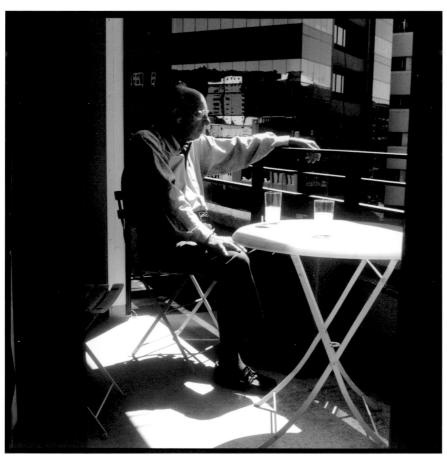

Gray's Visit, 2000

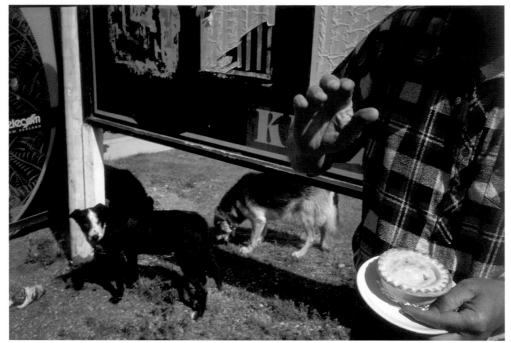

K, 1999

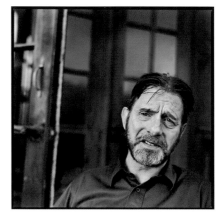

Jack, 1995

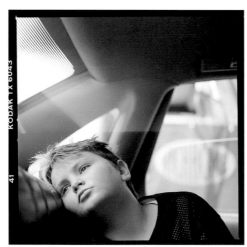

Late, N.Y.C., 1999

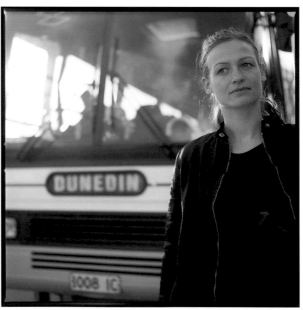

Dunedin, 2000

Mortensen's photographs, the man has no face and the moment centers on gestural body language. Three blooming adolescents with their Barbie dolls and cascading platinum hair, who are both aware and unaware, pour their emerging smiling sexuality, vacuous but deliciously alive, into any roving eye (*Mermaids #3*, 1997), "much to the dismay of many mothers there,"[4] as Mortensen himself notes. Or Jack Kehoe, who wears the straggling desperations of his life on his forehead and under his eyes, the furrows found or dug, all held at a slant (*Jack*, 1995).

And Mortensen likes children, manifestly likes them. Why? There are no easy answers to such a question; however phrased, it seems soggy with cliché. Perhaps he is interested in the quality of their attention; the unqualified nature of what they have to say; their capacity to lose themselves in dream; the transparent complexity of their gaze. Or perhaps it is simply because they are ours. In all events, words trail away and the images take over. A young boy, caught in the dramatic shadow of his own condition (*Tommy Black*, 2001); a child with a toy (hopefully) gun, unruffled, hand supporting wrist, unwavering eyes and lethal intent (*Double Tap*, 1998); a kid in his upside-down world on a swing shouts "Where's Brigit?" to his mother, or his baby-sitter, or his absent sister, as he's watched with a mixed expression conveying partial exhaustion and some recognition that it may well be the $100 question (*Where's Brigit?*, 1995); a morose, don't-truck-with-me face over an imitation-leopard-spot jacket (*10 a.m.*, 1998) grows even more morose and unyielding (*10:02 a.m.*, 1998); a kid in a parked car waits endlessly for his parents, locked in his own thoughts that consist essentially of a litany of accusations (*Late, N.Y.C.*, 1999); a young boy pushes up against the glass of a Belfast shop window, forgetting reality and losing himself in a cluttered Aladdin's Cave display of small treasures which is pushed to the edge of the frame—as is much else in life (*Belfast Christmas*, 1992).

Mortensen gives us the sense of knowing and caring about these people. They are, in other words, album photos with an edge. They are unpretentiously human, colloquial, as simple and particular as American diction, and as careful about what they say as that diction should itself be. It seems possible that for Mortensen there is no objective world—except for that formed and shaped by the moment—since vision is multiple: it is a matter of seeing something clearly and making that clarity both the limit and the definition.

There is "no interval of manner,"[5] no self-conscious struggling for style, yet Mortensen does seem to be constantly testing his own small truths—by testing I mean holding them up to the light to see if they gather attention or itch with intrigue. He occasionally works in something akin to a series, but there is rarely any real chronology; it is almost as if true emotion follows space rather than time. One of these groups of photographs that can loosely be referred to as a series was taken in New Zealand while on location for *The Lord of the Rings*. The images are in no way related as a group, although some of them do relate to each other as a sequence. They again take up his concern with the language of gesture, with the eloquence of a minute change in a physical movement or with the way movements qualify each other and, if

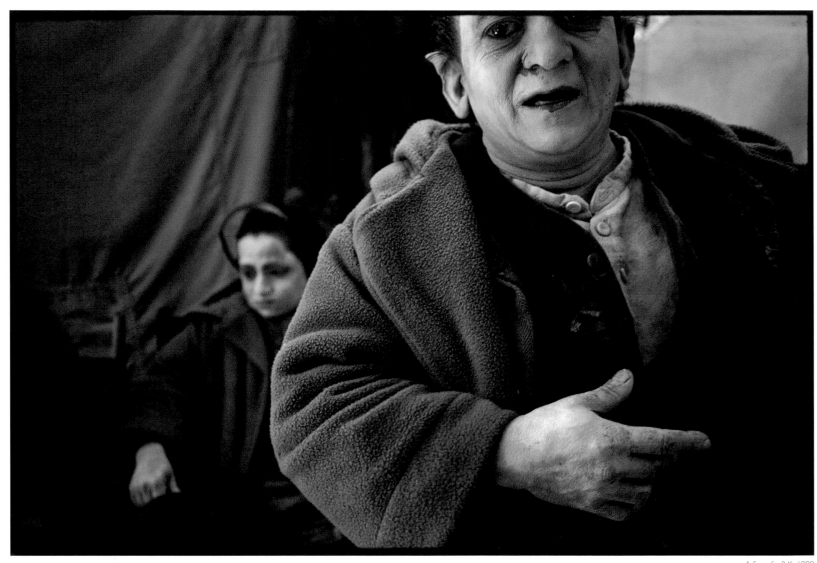

A Song for B.K., 1999

observed, will sometimes give witness to a knotting of emotions that words themselves cannot do. *A Song for B.K.* (1999) sets up a tight momentary relationship where, perhaps, there was none: two figures are near a kind of curtain-cum-door, which the one in the background appears to have just come through, as may have the foreground figure, with his cutoff, clown-like face. The distance between them has been fore-

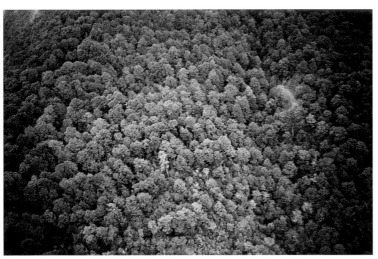

Chetwood Forest, 2000

shortened and tensed by the medium itself, leaving us with highly pictorial, almost Renaissance echoes; there is a kind of torqued, mannerist play between the diagonal line that links the faces and the horizontal lines that run across the bottom to link the figures' hands. This is an accident that the eye had been waiting for. We are not sure *what* it means, but we know it means.

In *Helm's Deep* (2000), Mortensen similarly allows a hand to speak, catching it as it moves across what appears to be a chain-mail shirt. The hand is out of focus; it is oversized, larger than life, and thus a strange protagonist. What is in the blurred movement, in the slight change in emphasis, in the smallness of the gesture? Is it something from the heart? Or is it

merely a habit? The chain-mail pullover seems to send its patterns over the hand, like a shed snakeskin, or the wind moving shadows across a field.

The *Chetwood Forest* group of images once again locates the strange, and even the awesome, within the real: here is a gothic darkness, a damp, saturated romanticism haunted by the presence of shadowy figures. These are animate woods stalked by the imaginations of J.R.R. Tolkien and Ursula K. Le Guin, a place where the roots of the trees are claws and the ground seethes with suspicion and movement. (No wonder Mortensen jots down in his notebook Aragorn's affirmation: ". . . have a care! Cut no living wood!") These are locations for goblins, witches, and spies, a terrain where the imagination can haunt itself, a place for the casting of spells. Yet Mortensen is not illustrating the bewitched climate of Romance; rather he is recognizing that language itself is a protagonist and that it is being raped of its mystery. Although spells have lost their charm—and even Snow White, as the novelist Donald Barthelme has indicated, ends up as the American housewife/horsewife—Mortensen notes with his own gentle irony that "spells repeatedly spoken to a person who believes the words have great power over him/her, cause them sometimes to die—of fright presumably . . . or, nowadays, of bore-dom." He knows that we live in a dark age of words, in a time when language is often misused. Words are beautiful, "both dying and deadly" as Mortensen notes, and they haunt this forest as shadows and metaphors, even as they remain intensely vulnerable and permeated by loss:

The time has come
when casting spells is
no more use against the
enemy we face than the
truest yearning of your heart.[6]

He asks us to distinguish among the shadows, to recognize our own feelings. He quotes Tolkien as if to indicate the constant dilemma of interpretation: "Good and ill have not changed since yesteryear; nor are they one thing among Elves and Dwarves and another among Men. It is a man's part to discern them as much in the Golden Wood as in his own house."[7]

The Amsterdam "series" has Mortensen on a journey with Dennis Hopper, refocusing the world through a similar errant eye. In *Amsterdam #5 and #6* (2001) we are confronted by two square images of a man taking photographs of a section of wall as somebody in the foreground observes him. Everything is in soft focus, the distance between the two people is tightened and cut, and all is bathed in a disturbing, saturated blue and black. In one image the second person stands at the edge, as if intruding, hand hanging loosely by her side, while in the other image the hand becomes clenched, clawlike, full of nervous tension. In the first photograph it would appear that nothing much is happening; a casual observer caught in the frame of that moment; in the

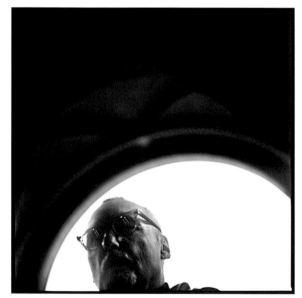

Amsterdam #7, 2001

second a tension has developed—the observer, whose presence is still unexplained, is grasping a dark object and our eye is directed to the wall, to a messy patch of paint and a small blue door. Additionally, as if to play with the entire range of expectations, there is somebody unseen behind the observer—Mortensen himself.

This is a photography of understatement, even absence—there is always a sense that what's there could be something else. That is perhaps a silly thing to say, but what I mean is that it could have been something else in terms of its importance in the world, which is very distinct from its importance to Mortensen himself. He is not dealing in content; rather, he is locating "lyric valuables." The images make us feel something, but we do not have to know what it is we are actually looking at: the literal falls into insignificance. There is, for example, a photo of Hopper taking a photo in a kind of double act of voyeurism (*Amsterdam #8*, 2001). The subject is a rainbow of colors with the suggestion of a body in a window. Or is it a window, a mural, another wall? Does it matter?

An ongoing series—which seems a rather forced term for what is simply a natural act—chronicles the life of his son Henry. These images are a kind of family album that unpretentiously details the warm silliness and sloppiness of it all; these are the jotted notes of the tiny events that actually give our lives meaning. However, beneath the sentiment Mortensen is always looking for that small immediacy, the formal hold, unexpected but imperative, that lifts the work to another level. *Celt* (2000) shows a boy, covered in

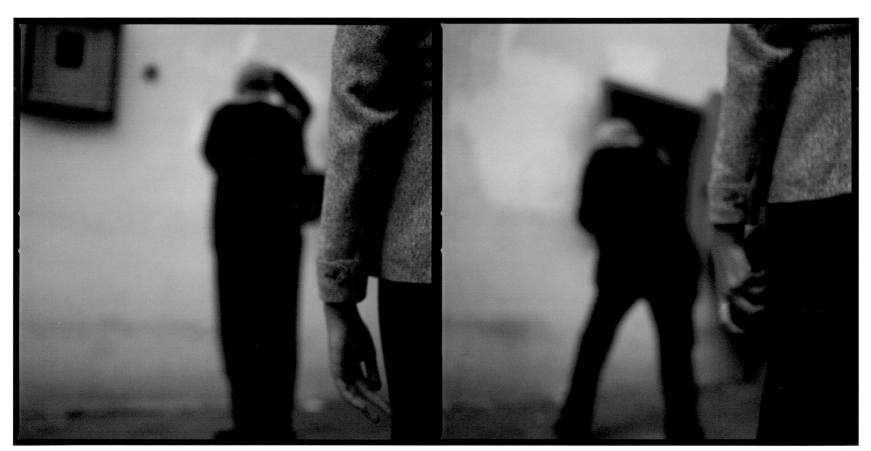

Amsterdam #5 and #6, 2001

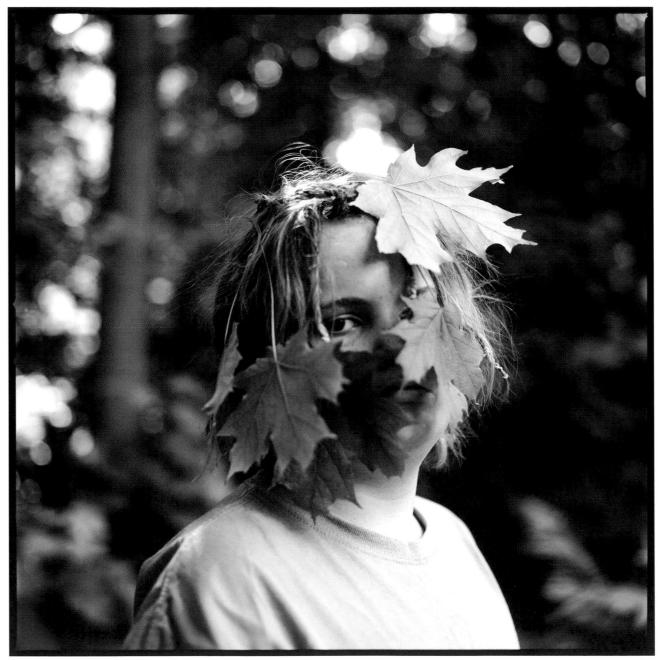

Celt, 2000

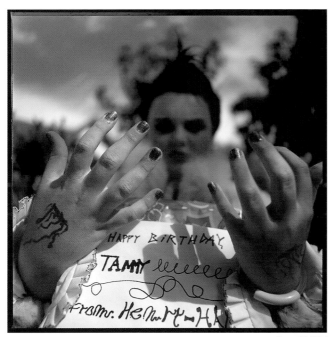

Green #9, 2001

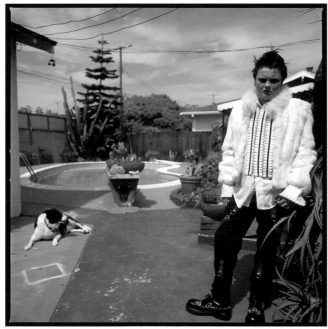

Going Out #3, 2001

leaves and soot as a kind of camouflage, held in a drama of brown and black. In *Green #9* (2001), we see a birthday party; the boy wears festive green nail polish and has a red stigmata-like felt pen scrawl on the back of his hands, and these colors are reiterated in the gift wrapping. Here is the apprenticeship of giving and receiving, the commercial mush of it all, and the momentary ebullience of being young. *Going Out #3* (2001), is an image connected perhaps to the same party; Henry is dressed to kill, but what brings the moment into a turbulence of meaning is the play between the boy's clothes and the dog; the red straps on his trousers and the vertical line of the flowers; the boomerang effect of the shot from boy to dog to the edge of the pool to the wall of the house.

Mortensen's paintings relate to his photography in the sense that they also teem with lived incidents. They are collages, brushings of materials and words, all used, felt, and constantly touched. Redefined and restated, there is always something beneath, rubbed out, obliterated, nuanced; there is always more happening. Words from his poems, found phrases, or overheard whispers both succumb and survive as they enter the field of the work. These inclusive works are nostalgic for the worn, for textures and endless qualifications. Mortensen notes of his constant recourse to language within them:

> Viz my own poetry and words in
> general, whether they be heard,
> read, imagined, crudely translated,
> used as emotional springboards,
> found in sagas, personal letters,

La Selva, 1999

news stories, novels, want ads, road signs, crosswalks, on t-shirts, cars, trucks, trains, pill bottles, skywriting, leaves, petals, gum wrappers, etc., I find that in the last two years I've tended to use them in fragmentary fashion, as paint. The paintings I'm working on now have words, phrases, bits of information, received wisdom, journal entries, admonitions, all used in blended layers. Sometimes no more than a few words can be read on any given patch of canvas, wood, or other painted surface. They are often painted over, written over, sanded, rewritten, crossed out, re-painted, re-sanded, re-written, etc. No longer care if I've forgotten them myself. Have gradually ceased copying them into journals or onto the kitchen wall so as not to lose them. They are there, buried, hinting at previous points of view, experience.[8]

Mortensen has a disposition towards an archaeology of emotions, of things that are buried, weathered but surviving along with the rest of us.

The paintings are bits and pieces, colors, letters, scraps, all brought together; they are comfortably frayed as a result of the give and take and at ease as a result of their mutual concessions—these fragmentary percep-

tions are aesthetically tuned to each other. *Isolation and Its Effects on Colour Perception With the Passing of Time* (1999) shows a crouching figure that seems to be terrified and vulnerable. It is overwhelmed by a tonal presence that suggests that everything should be accommodated—not accepted, but accommodated. In *La Selva* (1999), plants and snakelike figures in blue, red, black, and green haunt a saturated space that erodes tensions but insists that we live amidst our own accumulation of half-finished stories, layer upon layer. *Armstrong* (1998) is a collage that includes a piece of material with this highly evocative name on it—it is a found object that brings its own tango of associations, from music to space travel, from the name of the grocer around the corner to that of a friend. *"The Marvelous Impossibility of Reaching Her Through the Difference That Separates You"* (2000) incorporates a quote from Marguerite Duras, the exponent of the Nouveau Roman, along with drawings, fragments, swirls, and doodlings that allow, in classic terms, the things themselves to speak of what lies inside us. Most of the works are abstract, layered studies of color/texture. They are often sanded and repainted so that the words and whatever distinct imagery there might be are mostly veiled. Mortensen notes that he was impressed by Colin McCahon's "word and number" paintings: ". . . words, paint, words. Balance, blackness, nature, red, yellow, god, fear, godlessness, etc."[9] And he adds a telling phrase from McCahon himself concerning his own methodology: "Unless ye become as a little child ye shall not enter the kingdom of painting."[10] In short, he seeks in these works to remove the blocks of final prejudices in favor of an aesthetically organized play that uses the

experience of life, its bruises, simplicities, employing acquired filters of sensibility and patience rather than any platform of argument. Words are allowed to survive and come through under their own energies instead of being frozen, as it were, into larger meanings of syntax and logic. The phrases are open-ended, quaint, horrifying, outdated. They assert that everything is about language, and anything anybody says is worth looking at, even if it might be disavowed. In these works the handwriting is faster and increasingly less legible: "Words as paint."

His poems do carry the unforced, spontaneous diction of the Beats, but without any heavy protagonism of the marauding "I." They are laid-back, casually oneiric, constructed of fragmentary perceptions, dreamily discrete, and very much the voice of the man. The eye is exploratory by nature, and in Mortensen's poems it moves with speed and concentration, shifting vision and changing focus. This motion builds a pattern of equally shifting relationships, of "perceptual jolts," to use William C. Seitz's description of the impact of Pollock's work. These poems seem close to the way his mind works: things tend to be collaged in where they almost fit, or, more precisely, they fit in the only way they can: almost.

I have mentioned Pollock, Creeley, and the Beats, just as I might have also talked of Richard Brautigan or Robert Frank. Mortensen's work, in all its forms, feels the impact of this fifties/sixties generation that set an agenda for American culture as the shape of a highly particular experience. Let me apply Ronald Sukenick's remark about fiction to Mortensen's creative stance:

Karen Blixen's Birds (detail), 2001

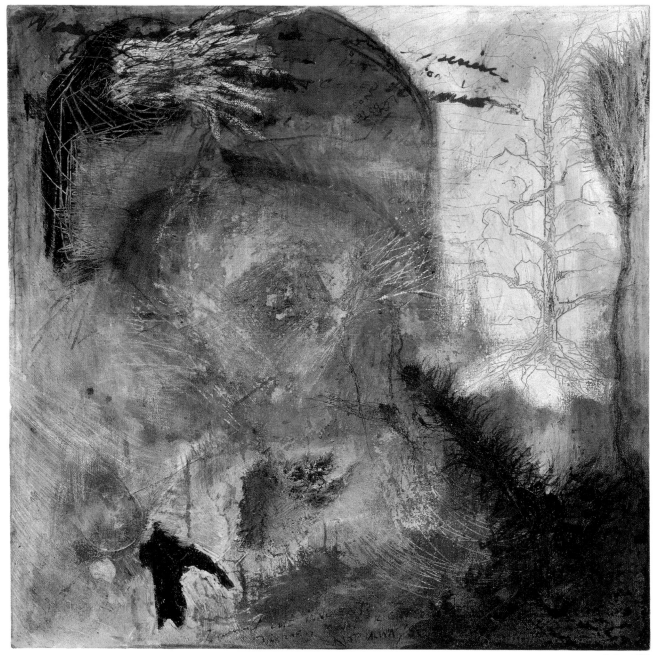

Entierro, 2001

"The idea of fiction being neither a model of the world nor a mirror of the process of the real, but the incorporation of present experience (and one's imaginative reaction to it) at the same level of other data."[11] There is a playfulness at work which shows a strong degree of self-confidence and an essential modesty that amounts to an ethic; the overriding sense is that the perceived reality of things has become absolutely problematic.

The horizon is what we can take in with a single glance, said the poet Ed Dorn, and Mortensen frequently uses it, rarely making an effort to create vertical symbolic structures beyond those of plants, trees, and man. He deals with what he has around him, wherever he is—Amsterdam, New Zealand, L.A., whether he's in front of a television set, at somebody's house, or in the street. His work suggests an immanentist view of life where experience has value without the artist intervening to rearrange and structure it; there is an emphasis on the innate harmony between the world and the mind that is open to and actively participating in it. Mortensen has no trouble with pure contiguity. Things are there because they are there, and they need no glue of

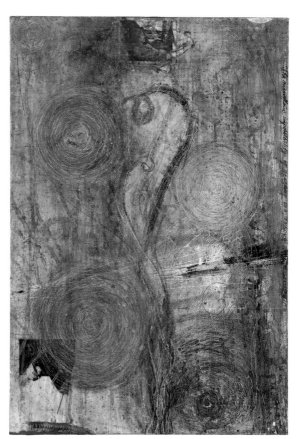

"The Marvelous Impossibility of Reaching Her Through the Difference That Separates You," 2000

syntax, no justification, no ordering of scale, shape, or focus. Truth, if anywhere, is in ongoing life.

Thoughts, like objective phenomena, are variable eventualities that come and go, glow and fade, attract or repel or summon each other, may even swarm and bleed—only in episodes do they arrange themselves into syllogistic or dialectical figures. And Mortensen certainly exploits ambiguities in terms of shallow space, accident, or willful blur. Donald Sutherland wrote about the power of ambiguity in his splendid essay "On Romanticism":

The distances in the third dimension should be exploited in preference to those on the plane, since the former allow a greater variety and complexity of scale, tone, and visibility, as well as making the space more permeable to the imagination. The mere leaving of one figure partly behind another breaks up the silhouette of the back figure, destroys the completeness of its explicit being, reduces it to disjunct variety, induces into it suggestion, or even mystery, and so a kind of potentiality.[12]

Viggo Mortensen's photographs are not so much about something—the subject matter is perhaps just one more element of the composition. Yet there is a recognition that any expression that bears on life at large builds from a need: 1. to do something with

something; 2. to do something with somebody; 3. to explore everyday reality and modify one's lifestyle to the point of risking existence itself. These are grand terms, paradigms for a lasting design, but they constitute a point of departure that Mortensen addresses on the modest scale of a particular human life. His work is a trace of his own adventure, lived openly and exploratively, with curiosity and a constant sense of surprise. The quantifiable givens and the minutiae of everyday subjects meet the unquantifiable risk—that of existing, which no ideology of "values" can ever cover. Culture, says critic Michel de Certeau, is only analogous to the wisdom that Don Juan, Carlos Castaneda's Yaqui sorcerer, defined—in the sense that we inspect a car's engine—"as the art of inspecting one's madness."[13]

Mortensen again and again focuses and frames his sense of being in the world, the strangeness of it, and his strangeness before it. He does not seek out the shockingly strange or rhetorically declarative, but he notices the sharp buzz of formal or color relationships that momentarily bring the contiguous into tension, as with the extraordinary *Chris' Dogs* (2001), where the two dogs come pelting through what appears to be an early morning mist to the shadowy figure of their master, a rush of darkness through a choking light. It is no wonder that he finds special relevance in Joseph Campbell's remark about "the beautiful organization of a fortunately composed work of art,"[14] or that Aragorn's words—"where sight fails the earth may bring us rumour"—resonate with him.[15] What Mortensen has done is to find and give shape to these small moments that keep us from sliding into the general entropy of it all.

Viggo Mortensen has used photography, painting, and poetry not so much to reflect his experiences, or simply as a diary of his own life, but rather to add what he seeks in order to record an imagination brushing up against a world whose meanings are constantly slipping. He has jotted down a phrase by Einstein in his notebook: "Art is an expression of the profoundest thoughts in the simplest way."[16] I guess he took this idea to heart, and remains, as he himself puts it, "inadvertently grateful."

Notes

1. Louis Zukofsky, "An Objective," in *Prepositions* (London: Rapp and Carroll, 1967), p. 20.
2. Robert Creeley, *Inside Out* (Sparrow 14) (Los Angeles: Black Sparrow Press, 1973), unpag.
3. Ibid.
4. Viggo Mortensen, "Spring Fair," in *Recent Forgeries* (Santa Monica, Calif.: Smart Art Press, 1999), p. 66.
5. George Oppen, *Collected Poems* (New York: New Directions, 1975), p. 185.
6. Viggo Mortensen, journal entry, 22 November 1999.
7. Ibid.
8. Mortensen, journal entry, 8 November 1999.
9. Mortensen, journal notes faxed to author.
10. Ibid. (Agnes Wood, *Colin McCahon: The Man and the Teacher*).
11. Ronald Sukenick, quoted in Jerry Klinkowitz, *The Life of Fiction* (Chicago: University of Illinois Press, 1977), p. 17. Originally published in *The Partisan Review* (winter 1976).
12. Donald Sutherland, *On Romanticism* (New York: New York University Press, 1972), p. 119.
13. Michel de Certeau, *Culture in the Plural* (Minneapolis: University of Minnesota Press, 1997), p. 147.
14. Joseph Campbell, *The Power of Myth* (New York: Doubleday, 1988), p. 55.
15. Mortensen, journal notes faxed to author (J.R.R. Tolkien, *The Two Towers*).
16. Mortensen, journal notes faxed to author.

Kevin Power holds the Chair in American Literature at the University of Alicante in Spain. He has curated exhibitions of the work of Julian Schnabel, Juan Usle, Ferran Garcia Sevilla, and James Lee Byars. He has written nine books of poetry, as well as a libretto for *The Cycle of Disquietude*, with music by Michael Nyman.

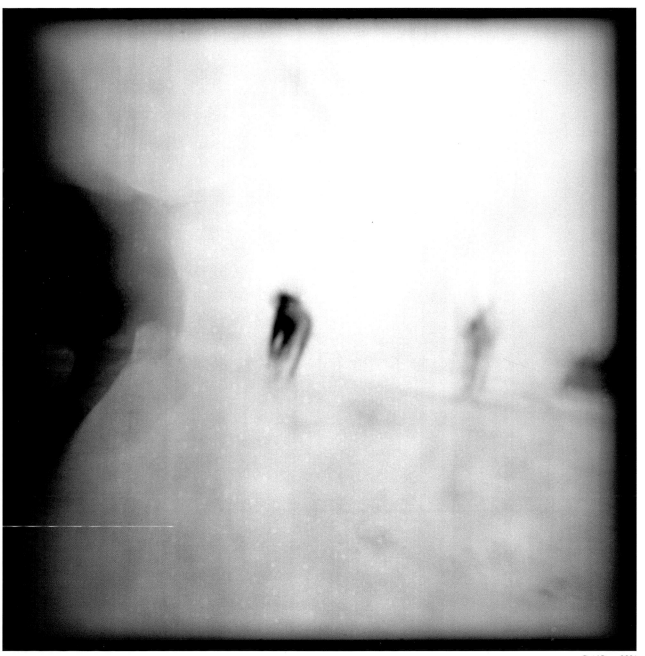

Chris' Dogs, 2001

Subject, 2000

Precautions, 2000

Buddha in Mora, 1999

The Middle, 2000

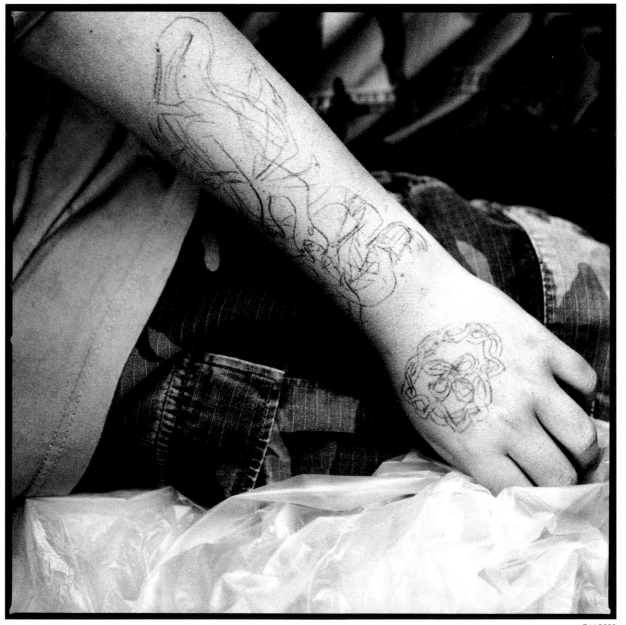

Told, 2000

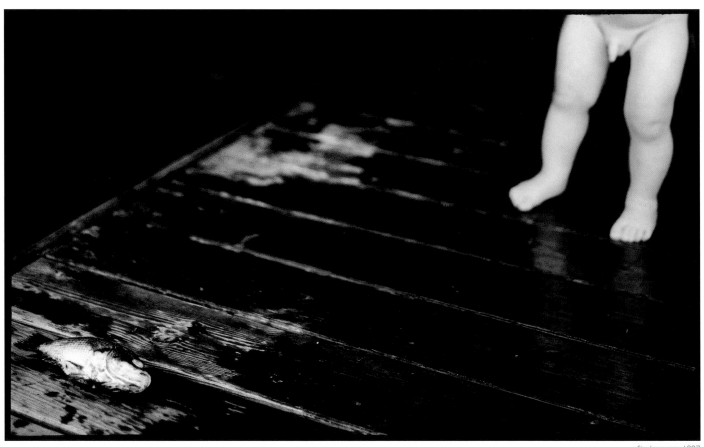

Signlanguage, 1997

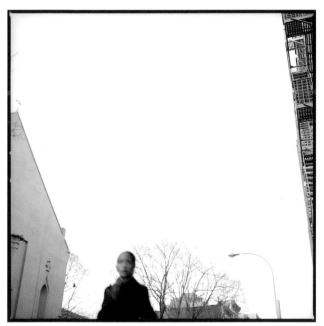

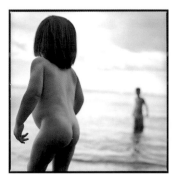

As One, 1997

Cold St. Patrick, 1998

With Jose, 2000

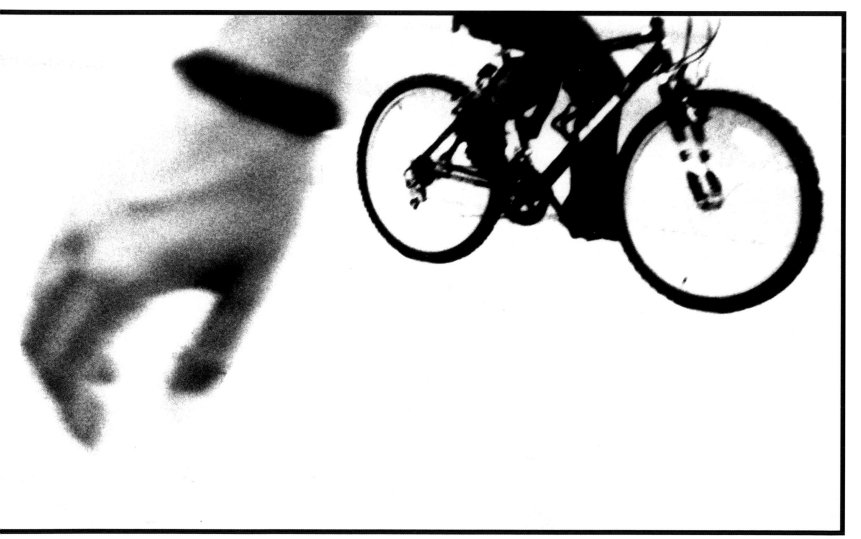

Winter, Venice, 2000

One Through Six, 2001

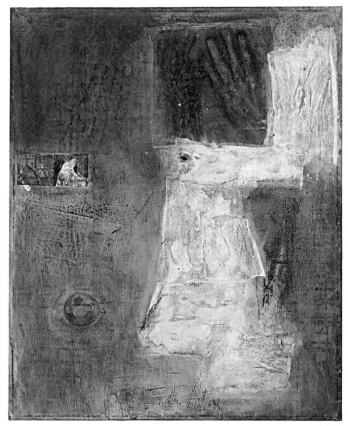

La conversacion que no tuvimos, 2001

Restos de un naufragio, 2001

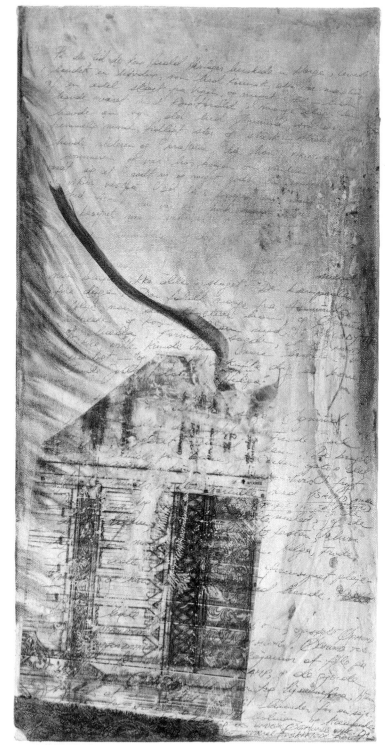

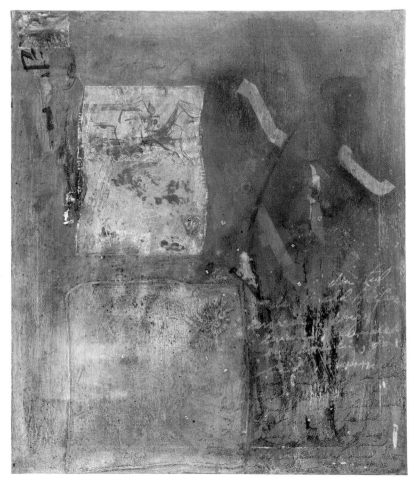

Kormak in New York, 2001

Kormak, 2001

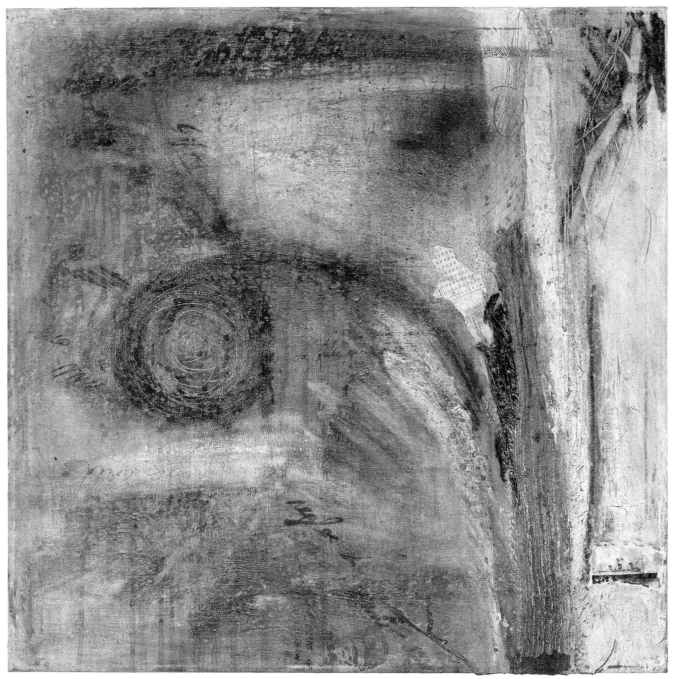

Elendil, 2001

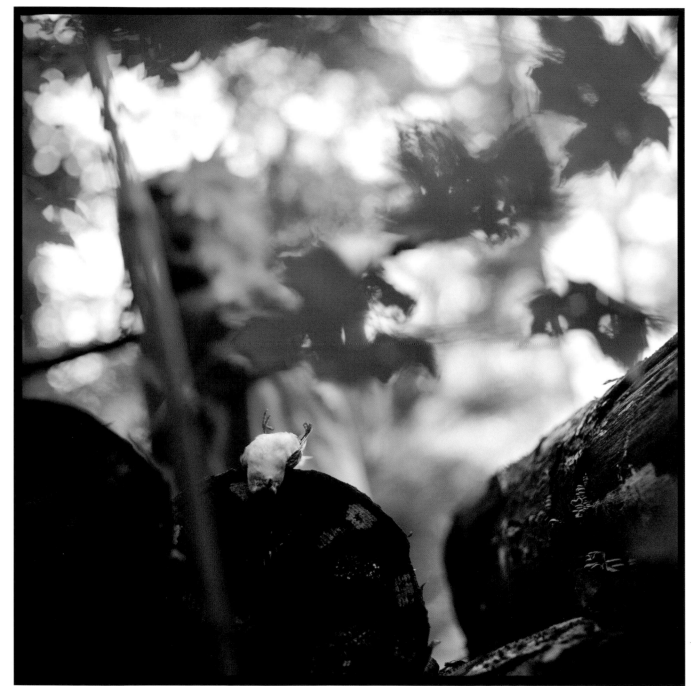

Fell, 2000

No Sign, 2001

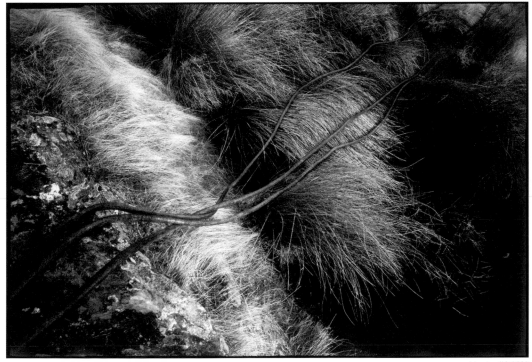

Intrusion #9, 2000

Lost #2, 2000

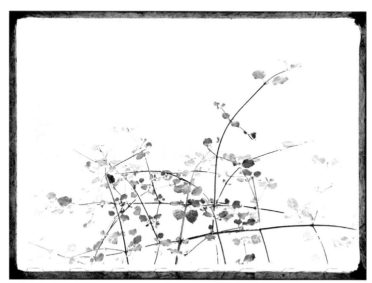

Lost, 2000

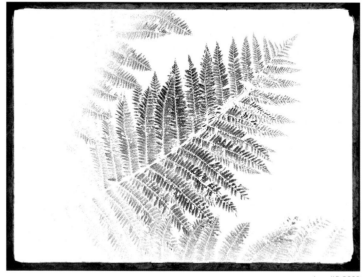

Lost #5, 2000

Lost #4, 2000

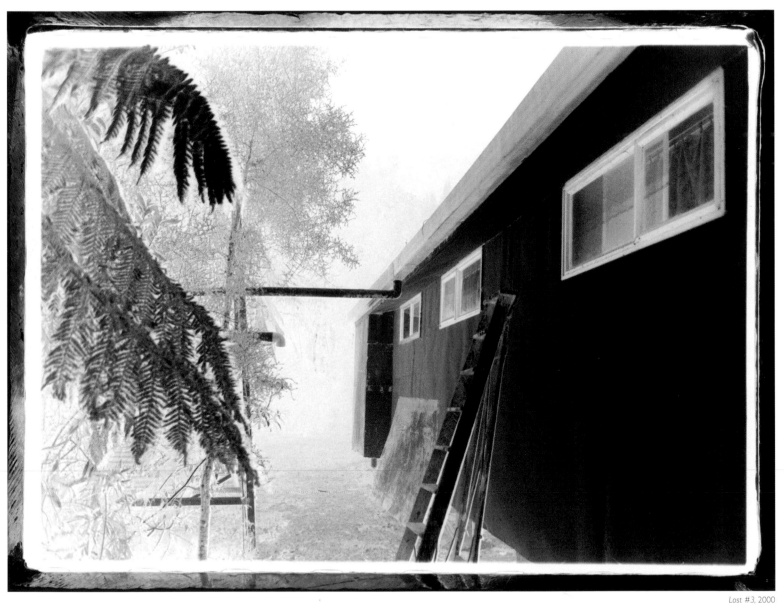

Lost #3, 2000

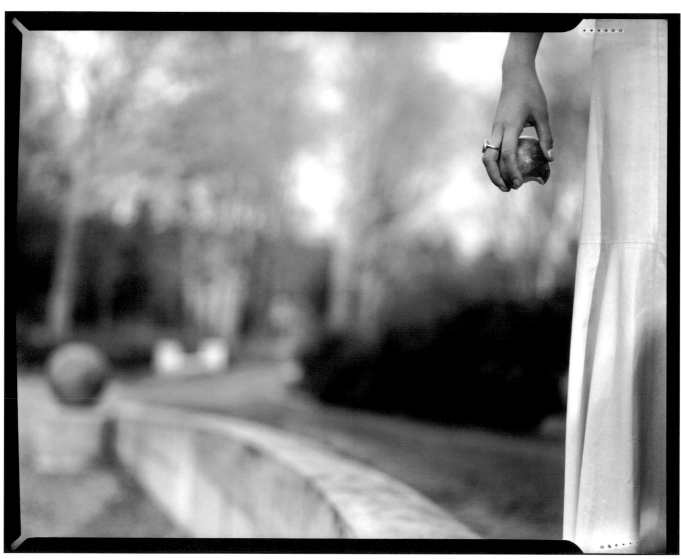

Wolvenbosch, 2001

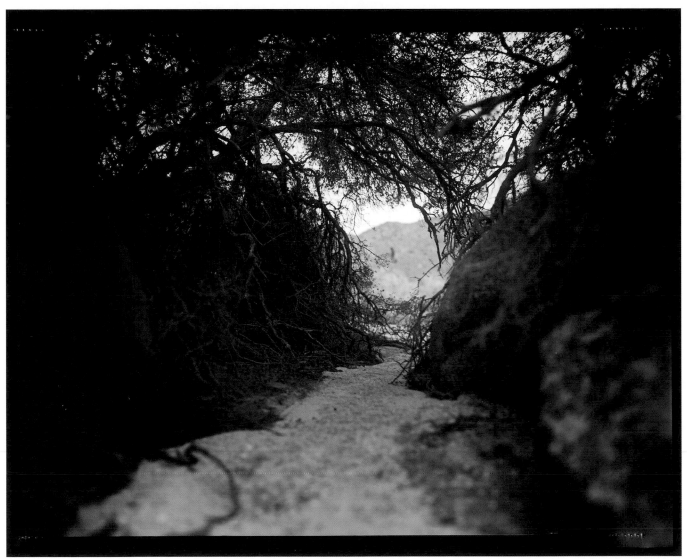

Element of Surprise, 2000

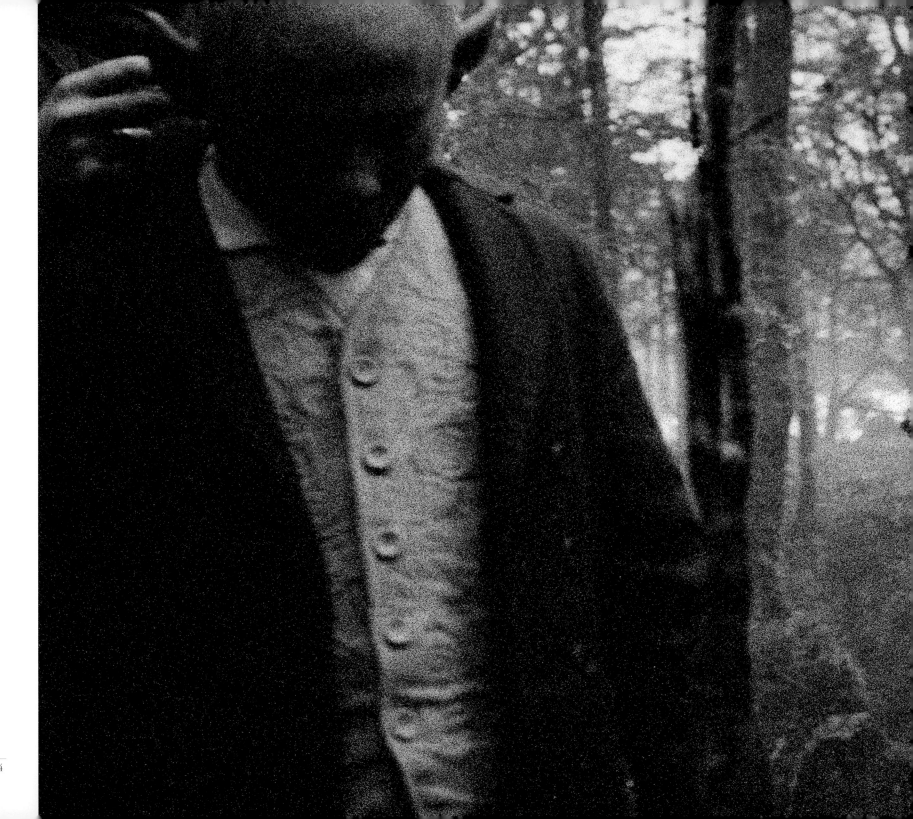

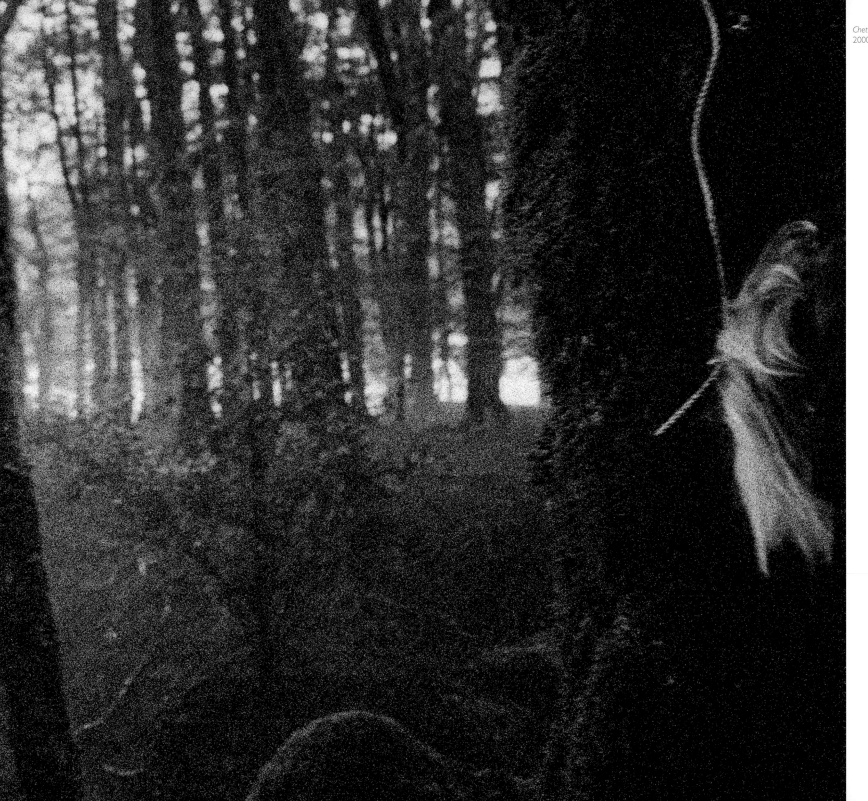

Chetwood Forest #3,
2000

45

Periodic Table, 2000

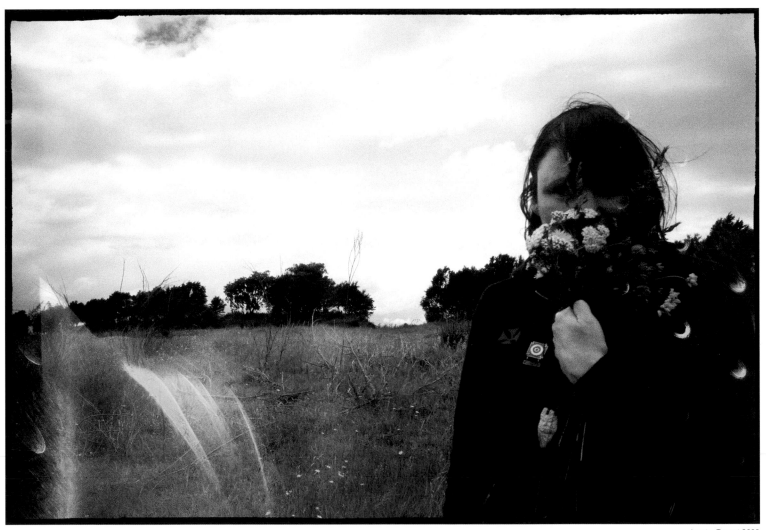

Leaving Turangi, 2000

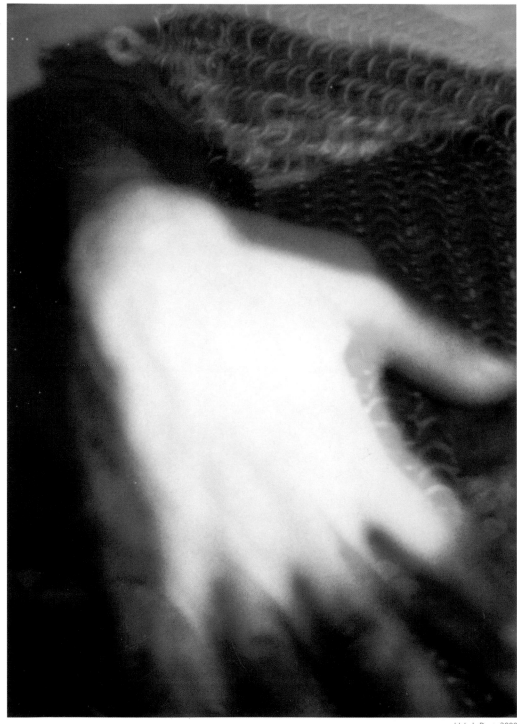

Helm's Deep, 2000

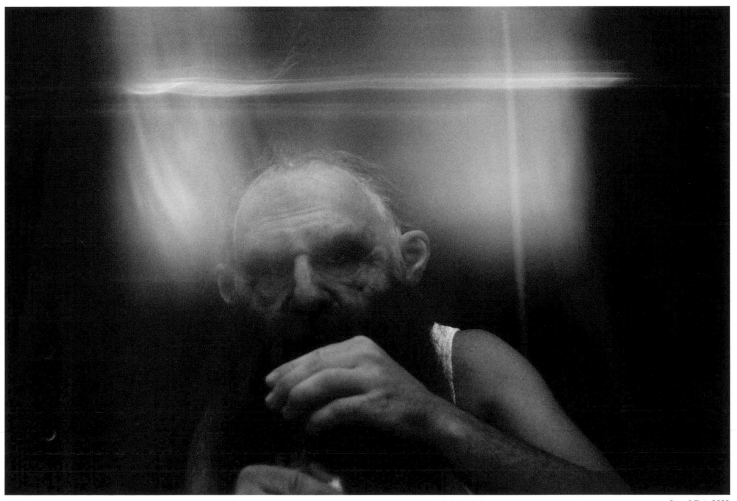

Son of Gloin, 2000

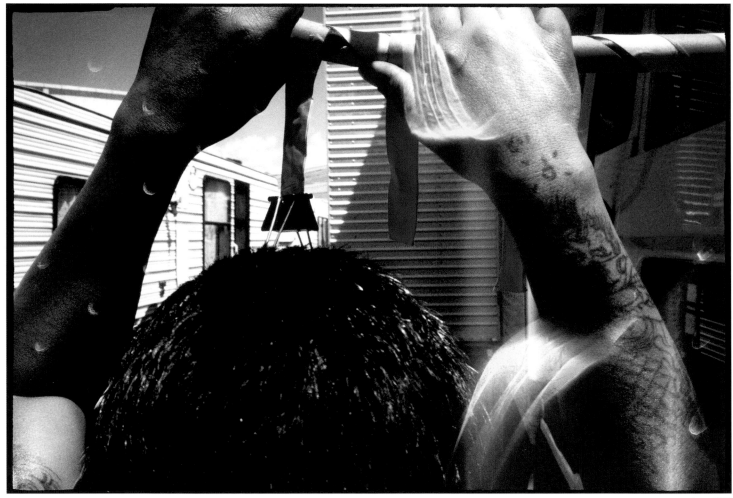

Jarem, 2000

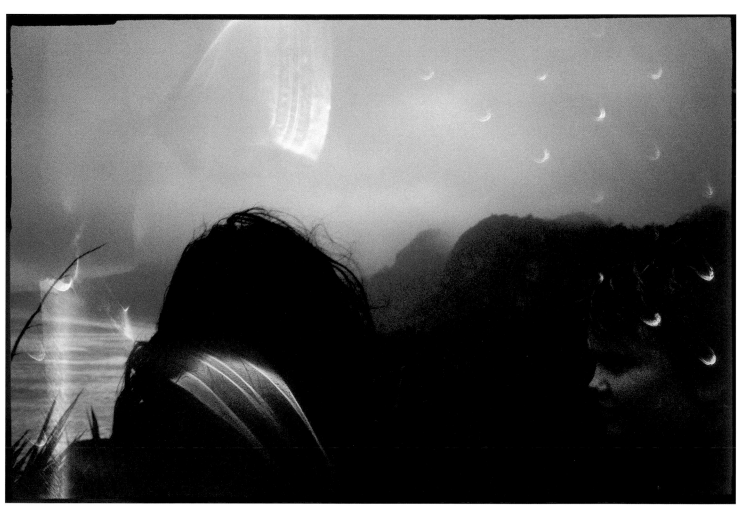

Westerly, 2000

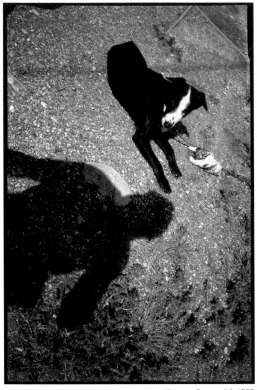

Kingston Corners #3, 1999

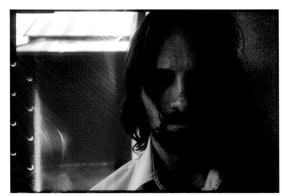

Later, Red, 2000

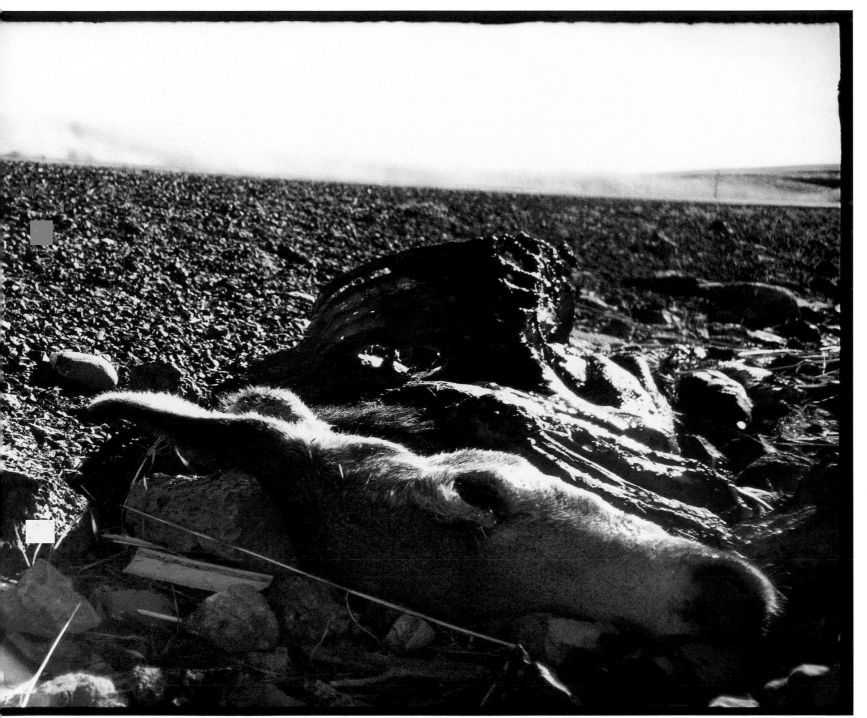

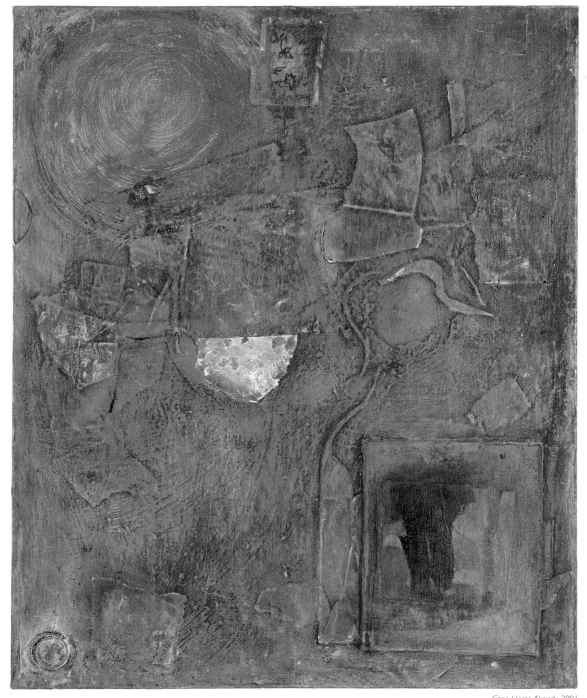

Gone Home Already, 2001

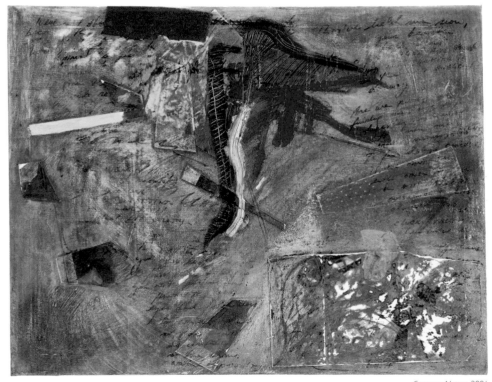

Common Nature, 2001

19 May, 2001

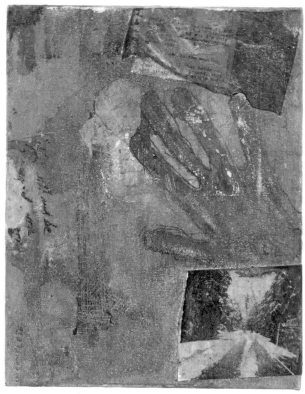

In the Birdsnest, 2001

Something Is Missing, 1999

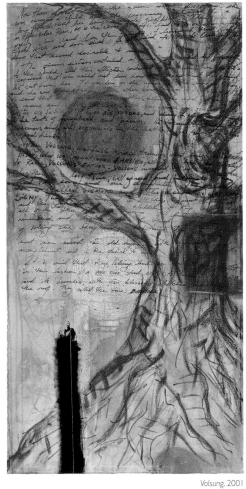

Volsung, 2001

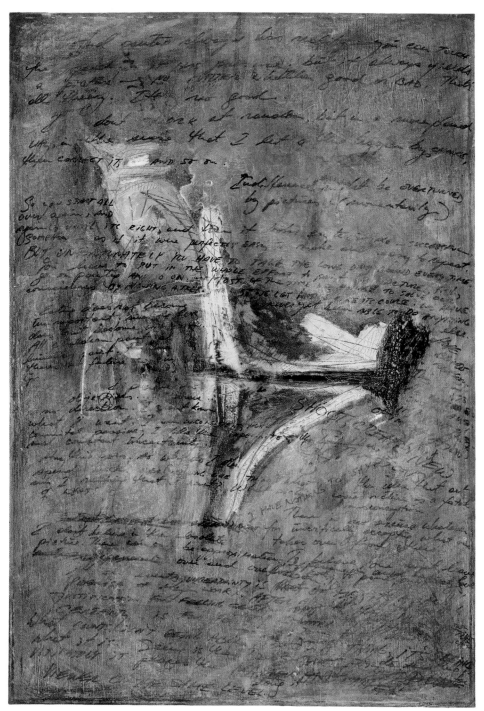

Reading Richter, 2001

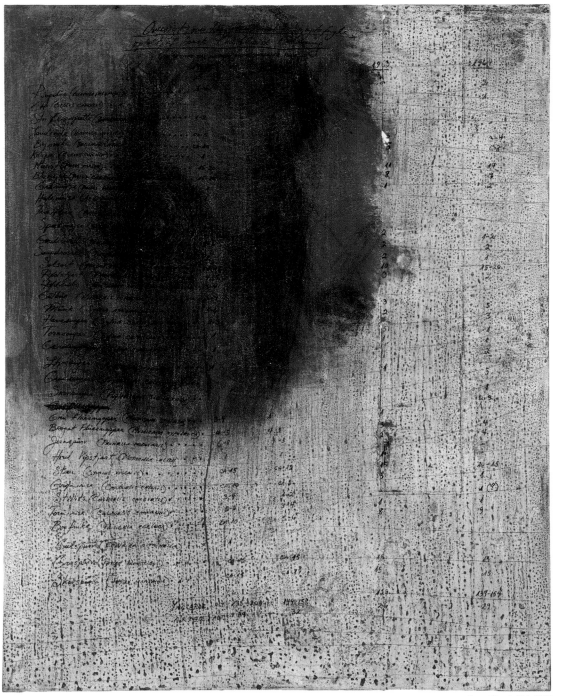

Karen Blixen's Birds, 2001

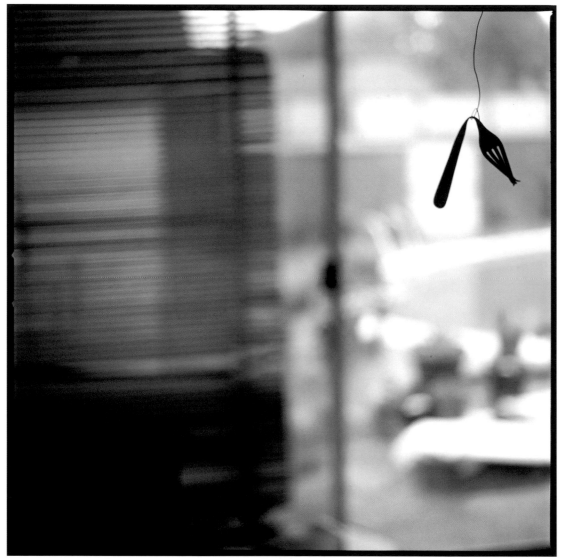

Passover, 2001

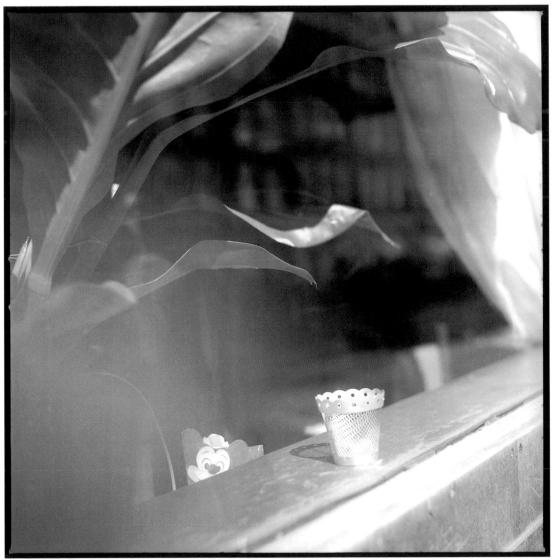

Amsterdam, 2001

Amsterdam #8, 2001

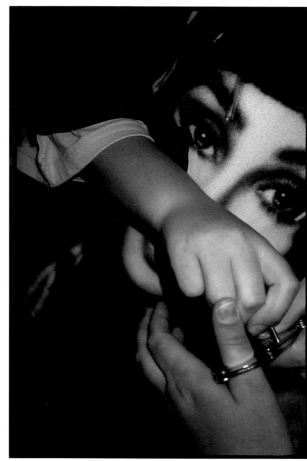

Las Vegas Is for Families, 1999

Amsterdam #2, 2001

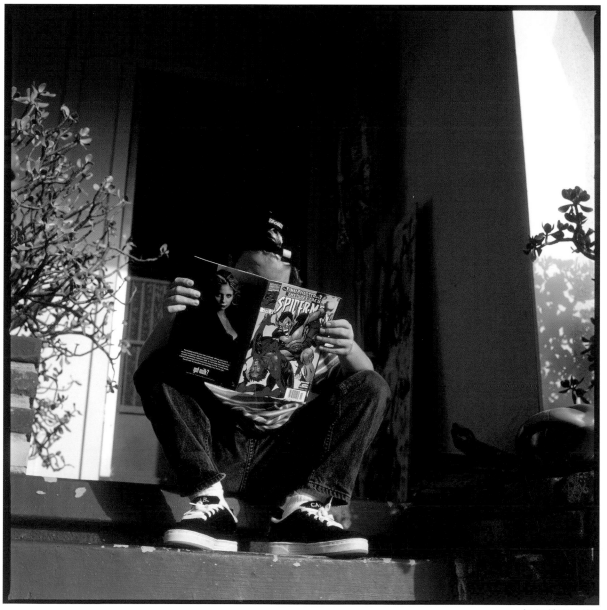

Sunday Afternoon, 1999

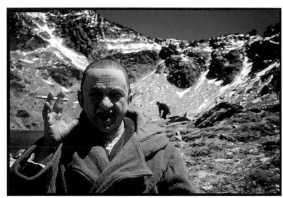

No One Can Know, 1999

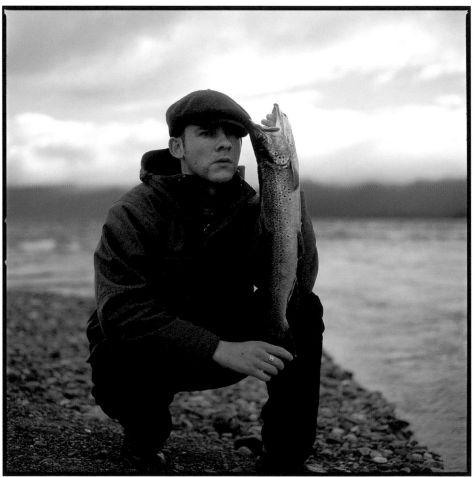

Dom, 2000

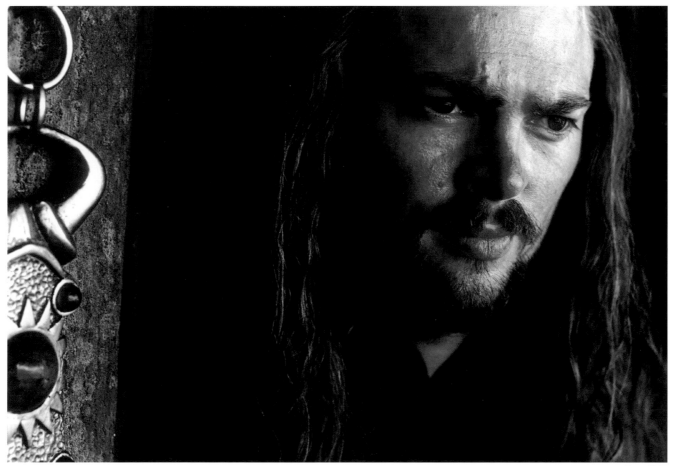

Eomer, 2000

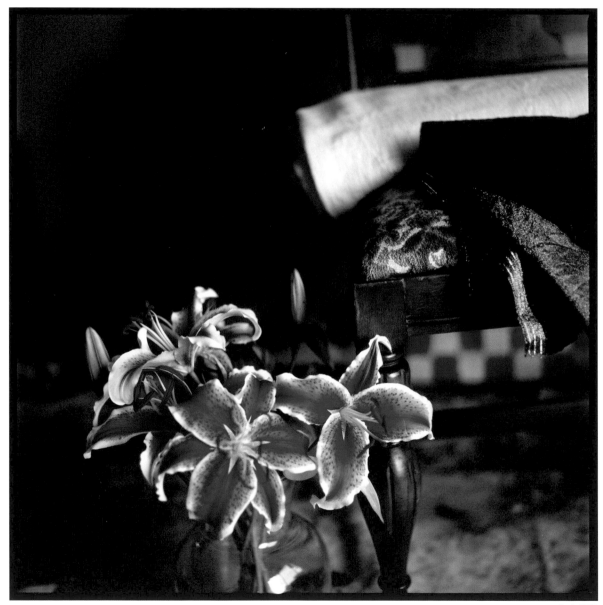

Studio, 2001

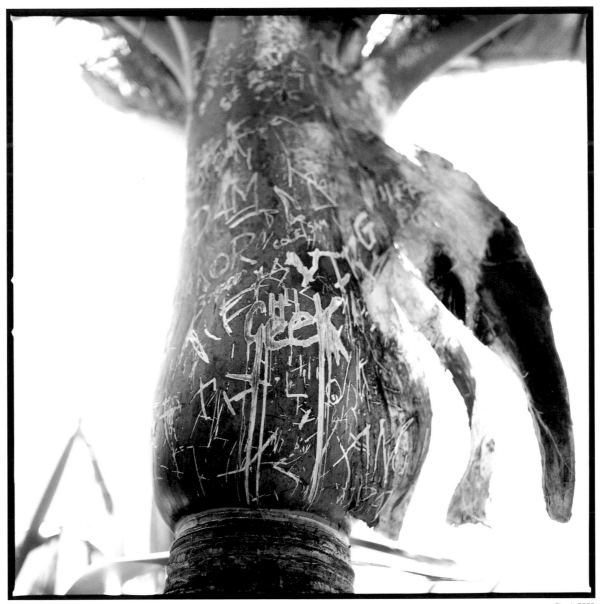

Cheek, 2000

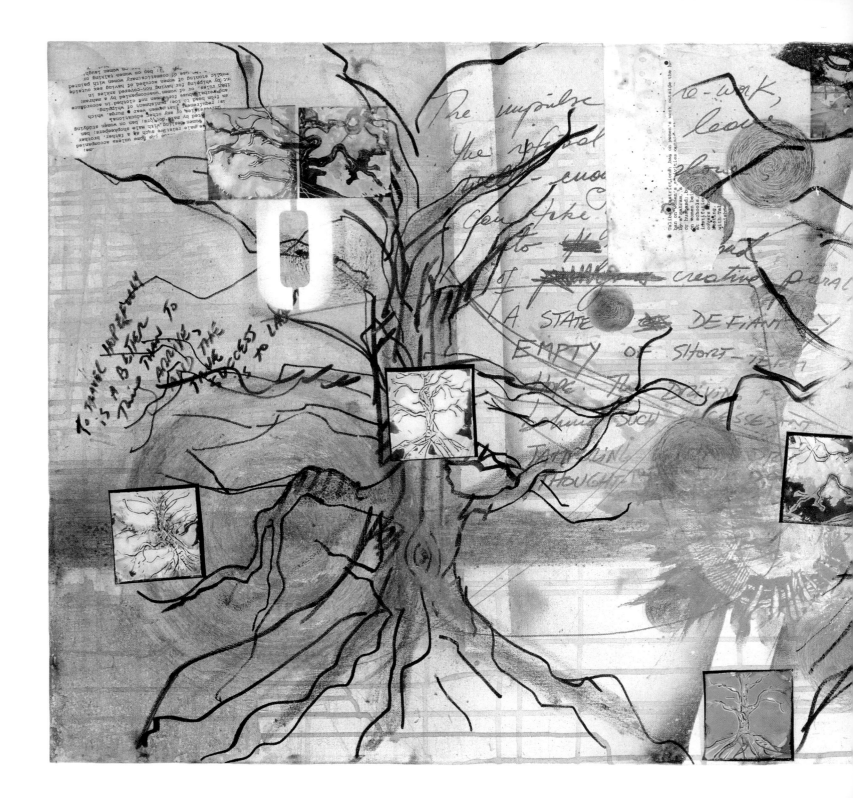

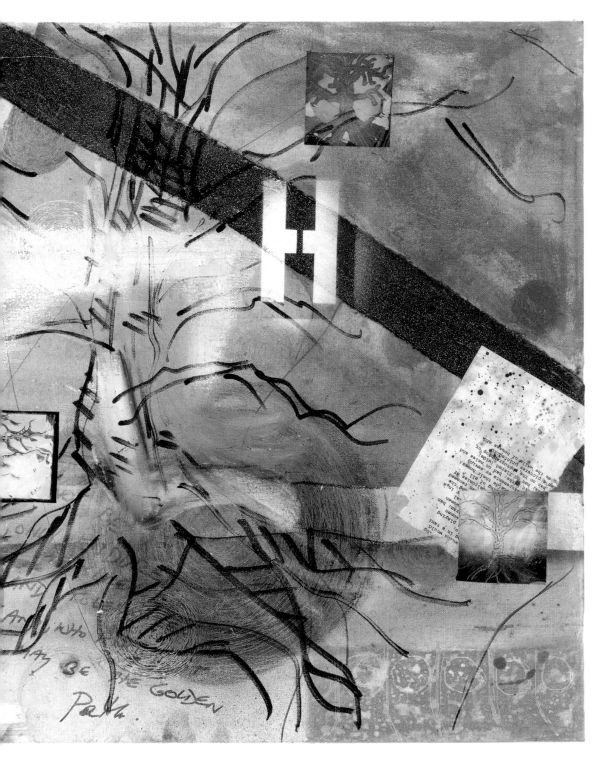

OH, 2001

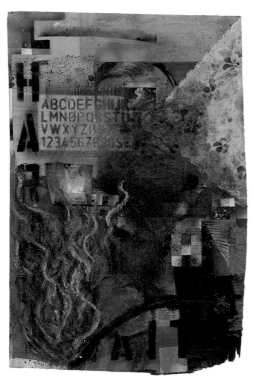

Hardly Wait, 1999

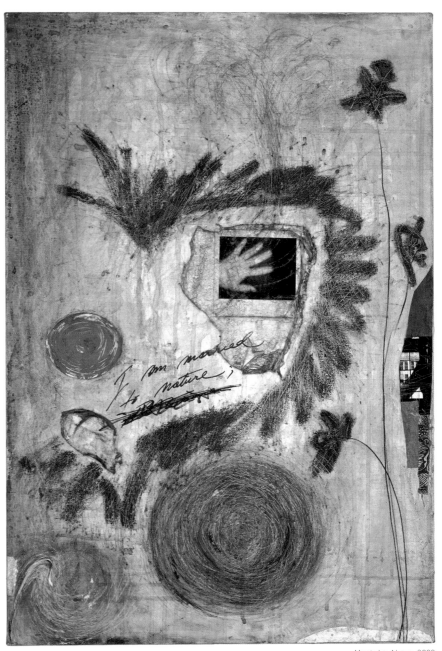

Married to Nature, 2000

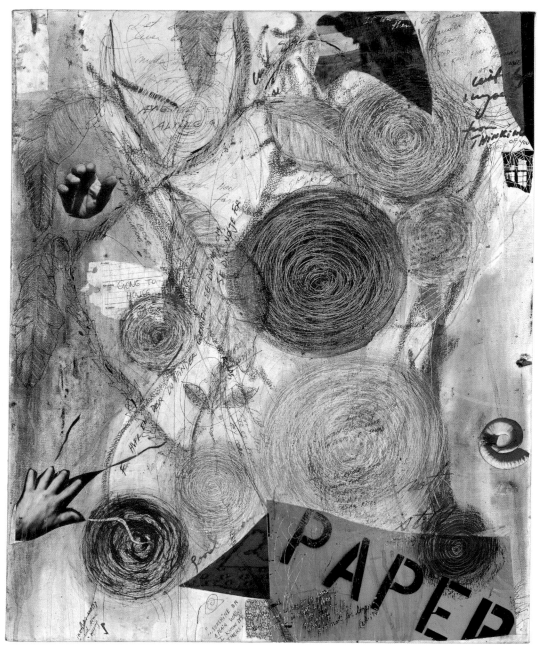

"Sunshine on a Plain Wall," 2000

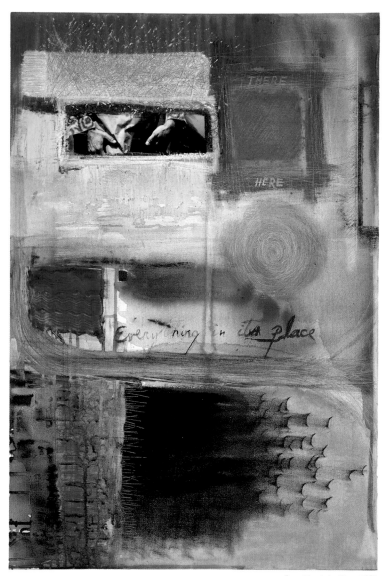

Prefiero equivocarme a mi manera, 1999

Everything in Its Place, 1999

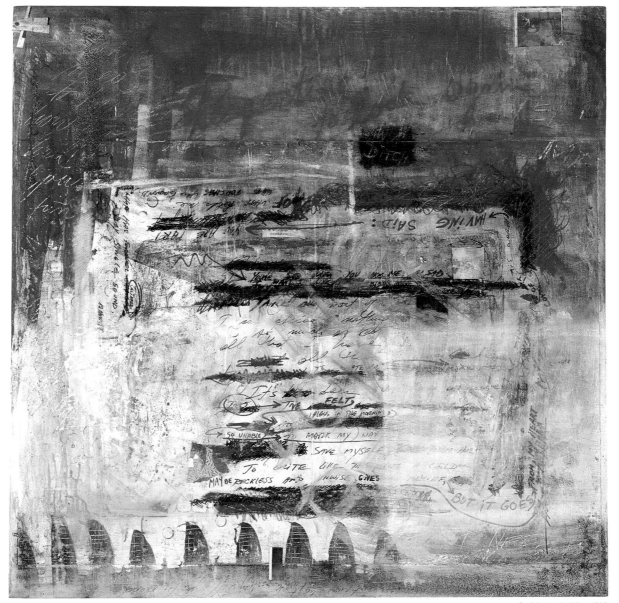

Sun's Losing Its Yellow, 1998

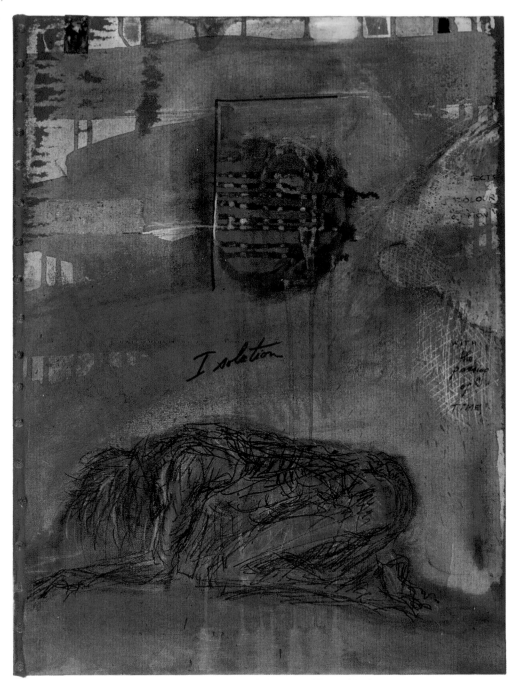

Isolation and Its Effects on Colour Perception With the Passing of Time, 1999

Red #25, 2001

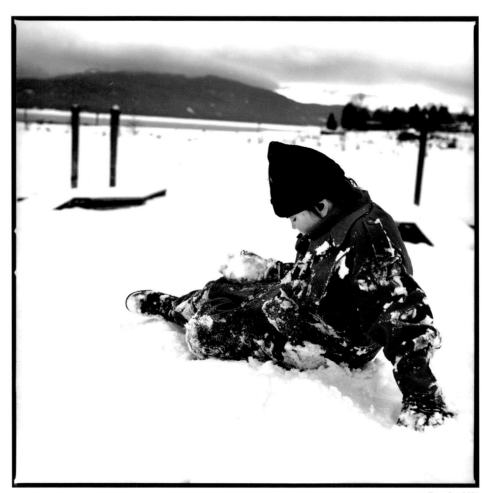

Time Out, 2001

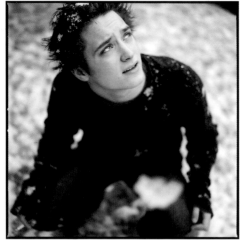

Te Anau #2, 1999

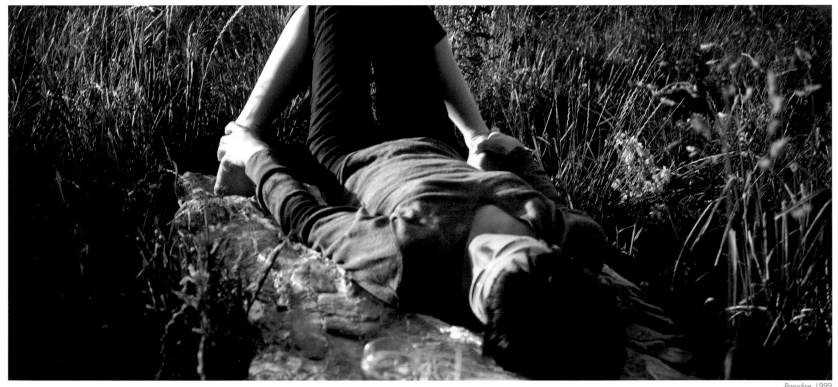

Paradise, 1999

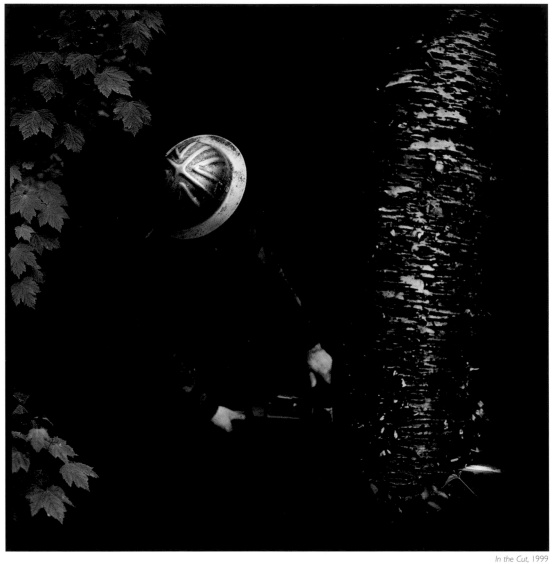

In the Cut, 1999

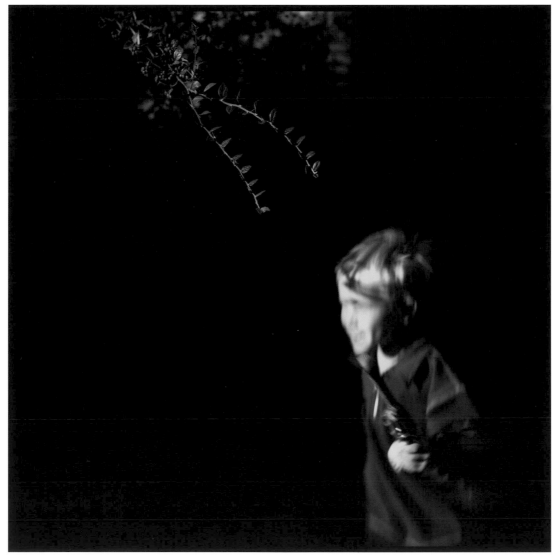

Mikkel, 1995

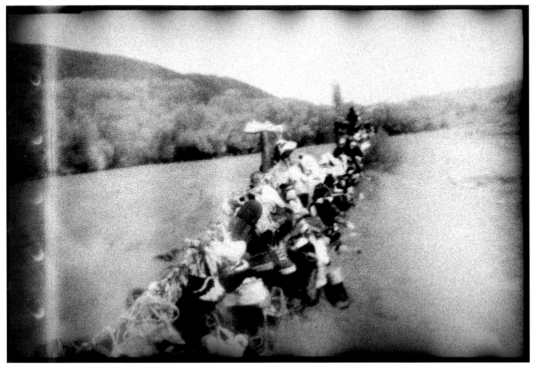

Shoe Fence, 2000

Irene's Window, 2001

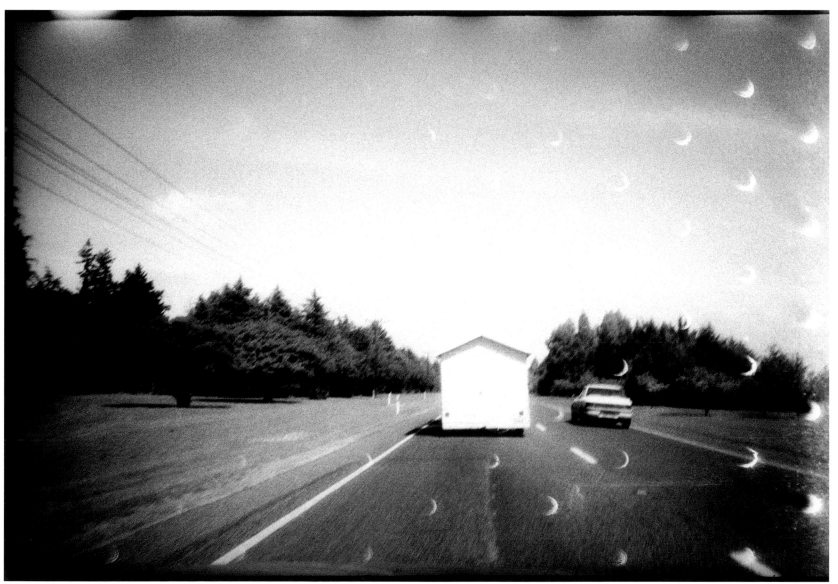

Leaving Christchurch, 2000

16th Oct., '98.

What I've noticed since
LEAVING THE GROUND:

~~History~~ Memory follows me.

To be ignorant
of the past
is a choice.
To accept it
in all forms,
from place to place,
continually ABSORBING
all moments possible
is not UNCERTAINTY,
is not NAÏVE.
It is willingness
to JOIN SOIL, SOUND,
HANDS.

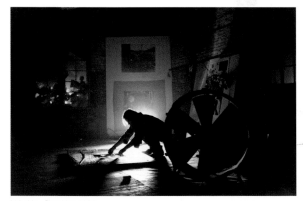
Working, Brooklyn, 1998

Journal entry, 1998

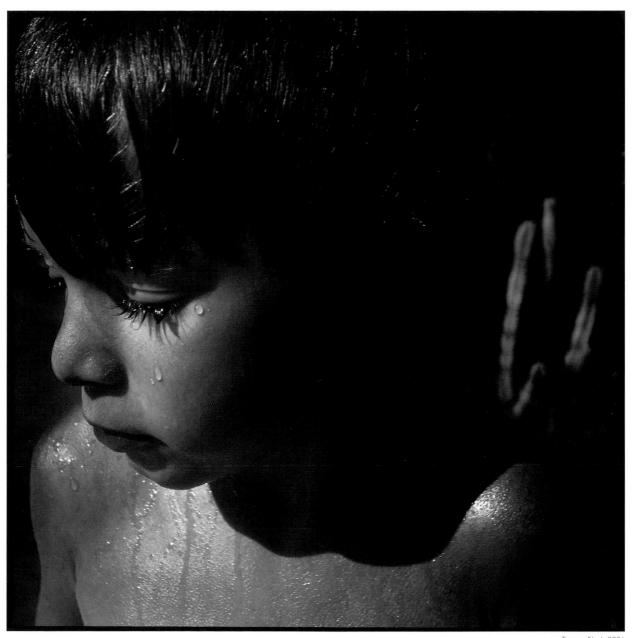

Tommy Black, 2001

SMART READER:

Viggo Mortensen (no relation)
has honored us once again
with his second Smart Art
Press—worthy publication—
this of his recent artwork—
esoterically introduced by
Kevin Power (no relation),
and edited by Pilar Perez
with a design assist from
Michele Perez (related).
Thank you one and all.

—TOM PATCHETT

SMART ART PRESS
2525 Michigan Avenue, C1
Santa Monica, CA 90404
(310) 264-4678 tel
(310) 264-4682 fax
www.smartartpress.com

1.

2.

3.

1. Viggo Mortensen: Recent Forgeries
Recent Forgeries is an extraordinary look into the mind of an artist whose boundless creative output touches a myriad of media, from photography to painting to poetry to acting. The writings, paintings, collages, and photographs in this book point to the fluidity of meaning in a world of flux. Includes a CD with music and spoken-word poetry. Introduction by Dennis Hopper.
Softcover, 7 3/4 × 7 3/4 inches
110 pp
54 color and 29 black-and-white reproductions
ISBN 1-889195-32-4
$25
1998

2. Christopher Doyle: A Cloud in Trousers
A Cloud in Trousers is a unique artist's book featuring photographs, collages, and writings that illuminate the often profound, sometimes bizarre worlds of cinematographer and photographer extraordinaire Christopher Doyle. Attesting to Doyle's ongoing obsessions with sex, light, and mystery, *A Cloud in Trousers* is a drunken ride through the thoughts and visions of an exceptional imagination.
Softcover, 11 3/4 × 8 1/4 inches
112 pp
Color reproductions throughout
ISBN 1-889195-33-2
$25
1998

3. Alan Rath: Robotics
A comprehensive designer, Alan Rath makes interdisciplinary art that incorporates his studies of human behavior, sociology, physics, chemistry, art history, artificial intelligence, and a fair dose of humor. Essay by critic David Ebony and an appreciation by Nobel laureate Murray Gell-Mann of the Santa Fe Institute.
Softcover, 9 × 11 1/2 inches
64 pp
41 color reproductions
ISBN 0-9650583-5-2
$25
Smart Art Press/SITE Santa Fe
1999